WOMAN

◆◆ A CELEBRATION ◆◆

WOMAN

◆◆ A CELEBRATION ◆◆

Edited by
Peter Fetterman

CHRONICLE BOOKS
SAN FRANCISCO

WOMAN

◆◆ A CELEBRATION ◆◆

Edited by
Peter Fetterman

CHRONICLE BOOKS
SAN FRANCISCO

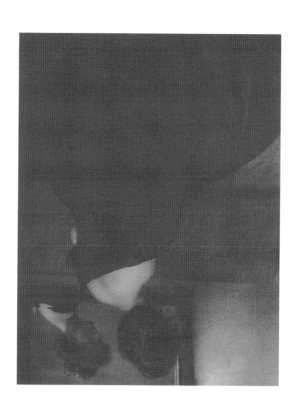

Cover image:
Kurt Hutton, "Fun Fair," 1938

Plate 1:
Robert Doisneau, "Be Bop á Saint Germain des près," Paris, 1949
©Robert Doisneau/ Rapho.

Plate 2:
Heinrich Kühn, "The Mirror," 1911

Library of Congress Cataloging-in-Publication Data available.

ISBN 0-8118-4098-0

Manufactured in China.

Book design by Scott Rivera

Distributed in Canada by Raincoast Books
9050 Shaughnessy Street
Vancouver, British Columbia V6P 6E5

10 9 8 7 6 5 4

Chronicle Books LLC
85 Second Street
San Francisco, California 94105

www.chroniclebooks.com

www.peterfetterman.com

Acknowledgments

For the women in my life: My wife, Martha; my daughters, Grace & Charlotte;
my mother-in-law, Gail; and my dear mother, Beatrice.

My first thanks go to the great photographers whose work inspired the book. I've had the great fortune to have known many of them personally. To those who came before my time, their legacy lives on.

My gratitude to Whoopi Goldberg for her heartfelt foreword. If ever a woman should be celebrated for her spirit and courage I know no better candidate. Scott Rivera for his elegant design and collaboration. Nion McEvoy for his initial enthusiasm, Alan Rapp my wonderful editor for his patience and intelligence in dealing with constant demands, and Jack Jensen and all the dedicated team at Chronicle Books for their encouragement and support. My colleagues at the gallery Kate Stevens, Marilyn Bacquer, Jennifer Pregenzer, Catherine Hollis, Felipe Manzo for all their extra hard work in addition to their normal duties.

The photographic community is filled with many dedicated individuals whose shared passion has fueled my own. David Strettell, Michael Shulman, Kim Bourus and James Danziger at Magnum Photos, Matthew Butson at Hulton Getty, Kathleen Grosset at Rapho, Marthe Smith and Amy Wong at the Life Gallery, Charles Schieps Jr. and Michael Stier at Condè Nast, Barbara Head Millstein & Ruth Janson at the Brooklyn Museum, Martine d'Astier & Selma Zarhloul at the Association des Amis de Jacques Henri Lartigue, Stanley Ackert & Daniel Gersen at the Lisette Model Foundation, Mack Lee, Gary Edwards, Dennis George Crow, Tony Davis, Stephen White, Ken and Jenny Jacobson, Alex Novak, Anne Baruch, Deborah Bell, Zelda Cheatle, Andrew Smith, Thomas and Wendy Halsted, Paul Hertzman and Susan Herzig, Robert Mann, Howard Greenberg, Rose Shoshana. William Schaeffer, Howard Schickler, John Stevenson, David Winter, Richard Whelan, Cornell Capa, Helen Wright, Robin Hurley, Nina Graybill, Mary Anne Helmholtz, Adam Gendell, Walt Burton, Bruce Kellner, Francoise Piffard, Susan Ehrens, Henry Rasmussen, Richard Rabinowitz, Bill Mindlin, Woodfin Camp, Teresa Engel, Merdidith Lue. Chris Karitezlis, James Markowitz, David Shaw, Joe Martinez , Monah Gettner, Bonni Benrubi, Alex Haas, Jim Farber, Ruth Silverman, Anthony Montoya, Laurence Miller, Joseph Bellows, Martha Schneider, Stephen Daiter, John Cleary, Henry Feldstein, Mary Engel, Denise Bethell, Christopher Mahoney, Daile Kaplan, Leila Buckjune, Amanda Doenitz, Lisa Newlin, Lydia Cresswell-Jones, Juliet Hacking, Therese Mulligan, Anthony Bannon, Susan Einstein, David Barenholtz, Robert Gurbo, Sarah Morthland.

Foreword

When my friend Peter asked me to write a little something about women for this visual celebration, I thought, OK, I'm a woman; I know women. This should be a snap.

But as I began to look through the book and its images, I was overwhelmed by the diversity of women represented in these photographs: mother and child, a woman in Vietnam hanging laundry, a charwoman on break. I saw women in all poses, in light and shadow, in sickness and in health; tragic faces matched with faces of joy, famous and anonymous, idealized, fêted, and cast aside.

I then realized that I am bringing my own experience to this collection, and that you the viewer will have your own journey through it. The joy here is not just in the quality of the art, but also in the wonderment at the who, what, where, when, and how of these women. Peter Fetterman and I, like good maître d's, welcome you and point you in the right direction, with thanks for coming and at journey's end, you will have stories of your own for each photograph.

Chances are if you are reading this book, it's either because you know, had, wanted, lost, loved, were, or are a woman. Whatever the reason is, when you're done you are going to want to reach out for the next woman you see, take a good look, give her a big hug, and be glad you know her.

—Whoopi Goldberg

"MY MEDIUM IS WOMAN"

— *Alfred Stieglitz*

As a collector and gallery owner, I'm often asked, "What makes a great photograph?" I always give the same answer: "A great photograph is like a great novel. You're one person before reading it and a different person afterward." I developed my passion for collecting photographs more than twenty-five years ago, before photography had achieved its current status. Museum shows were rare, books on photography barely got published, and it was still generally regarded as a second-class art form. It was possible back then for those of us with limited resources to acquire photographs; a group of colorful eccentrics driven by the love of the object rather than any secondary financial considerations.

I never consciously set out to collect images of women but one day as I dreamily looked around my home, I had an epiphany: that is precisely what I had done. Rather than seek professional analytical help on this matter, I decided that I had to produce this book. My walls had, in effect, duplicated my library. Hanging salon-style were the equivalents of *Anna Karenina, Madame Bovary, The House of Mirth, The Heart Is a Lonely Hunter,* and *The Color Purple,* to name just a few cherished novels. It seemed that some characters from these haunting books had come alive and been given visual form, conveying the same truths.

Why are women seemingly the most popular subject for the camera? Rather than provide a univocal reply, the wide breadth of images here seems to offer a wealth of different answers. The first, most obvious, reason lies in the examples of what are generally regarded as women famed for their physical beauty. Dennis Stock's exquisite portrait of Audrey Hepburn on the set of *Sabrina* (plate 8), speaks for itself, as does Allan Grant's magic moment backstage at the 1956 Academy Awards with two of cinema's reigning beauties of the day—Hepburn again, this time with Grace Kelly (plate 100). There are other classics: Napoleon Sarony's portrait of the great actress Sarah Bernhardt (plate 98), Ernst Haas's moody gem of the sultry femme fatale Eartha Kitt casting her magic on a nightclub audience (plate 58), and Baron De Meyer's image of Mary Pickford in her wedding dress (plate 24). Mark Shaw captured the magnificent aura of Jacqueline Kennedy (plate 37), and the only picture of Greta Garbo that I have ever seen in which she is smiling was taken by Clarence Sinclair Bull (plate 29). At the time, these were portraits of famous personalities; now they endure as icons of timeless beauty.

Side by side with these photos of well-known, glamorous women are those images of "unknown" women—often no less beautiful. Charles Scowen's portrait of a young Indian woman (plate 4) and the anonymous portrait of a young Japanese woman from the 1880's (plate 108) can hold their own with any celebrity shot. Edouard Boubat's adoring image of his first love, Lella (plate 35), has always been dear to me—his "Helen of Troy" shot, as I always call it, with a face that could surely launch a thousand ships. So, perhaps, could the gaze of the young Guatemalan woman in Luis González Palma's haunting "El Silencio" (plate 106).

The notion of beauty is hard to pin down. The dictionary gives us some guidance but it fails to cover all the ethereal implications of the word. Perhaps it is Keats's association of beauty with truth that better helps us understand the centrality of women in the history of photography.

Janine Niepce's extraordinary portrait of Colette (plate 86) is all attitude and determination; it elicits admiration for this strong woman who fought against convention and dared to write about subject matter hitherto taboo. Carl van Vechten's tender image of Ella Fitzgerald (plate 27) beautifully captures the soul of this supreme artist who, time and again, triumphed over extreme adversity.

Beyond the attributes of strength, resolve, and inner beauty lie the unguarded, spontaneous emotions that come through joy and celebration. Grace Robertson's humorous observations treat us to a special day in the lives of a group of working-class English women (plate 43). Each year they leave their men behind, hire a coach, fill the trunk with food and libations, and head off for the seaside. They have a jolly good time, returning to their homes late and slightly tipsy. Willy Ronis captured the simple joys of Parisian life as Europe slowly recovered from the scarcity of the war years (plate 72), and Bert Hardy, a wonderful English photojournalist, observed what women love to do best when they are alone together (plate 95).

I must confess, however, that the images that have haunted me the most over all these years are those that celebrate something other than the traditional. The power of an individual to change the world against indifference is shown

in Mary Ellen Mark's portrait of Mother Teresa (plate 61); the ability to endure and survive deprivation with hope comes through in Sebastião Salgado's "Mother & Child" (plate 33), from his Ethiopian series. If I had to articulate the underlying theme of this book through one image it would be Consuelo Kanaga's "She is a Tree of Life to Them" (plate 62). Not only is this one of the greatest, least-known masterpieces of twentieth-century photography—in its own way as great as Dorothea Lange's "Migrant Mother"—it also has one of the greatest titles ever given to a photograph.

Collectors are only temporary custodians of their objects of desire. Those objects, having given great pleasure and knowledge, should be passed on to the next generation. I'm very honored to share these images with you. I offer them with the greatest respect and admiration for their subject matter, for their strength, for their intelligence, compassion, beauty, humor, elegance, and style. They are examples of photography's true gift, the power to immortalize moments that transcend the passing of time.

—*Peter Fetterman*

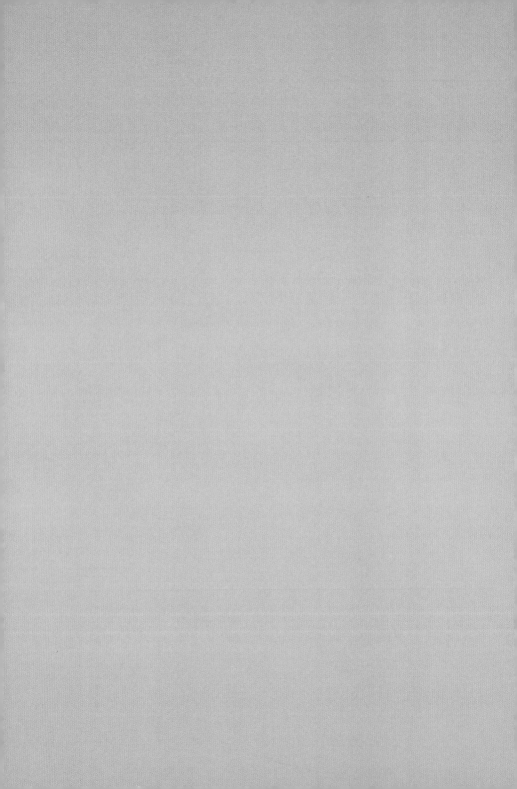

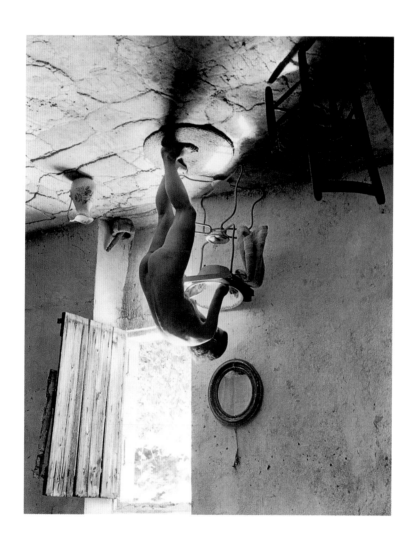

Plate 3

NU PROVENÇAL, 1949

Willy Ronis

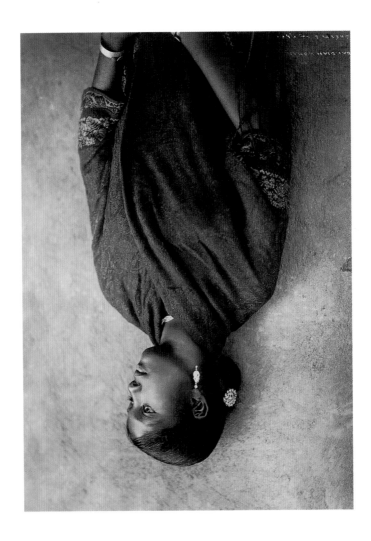

Plate 4

INDIAN WOMAN, c. 1870

Charles Scowen

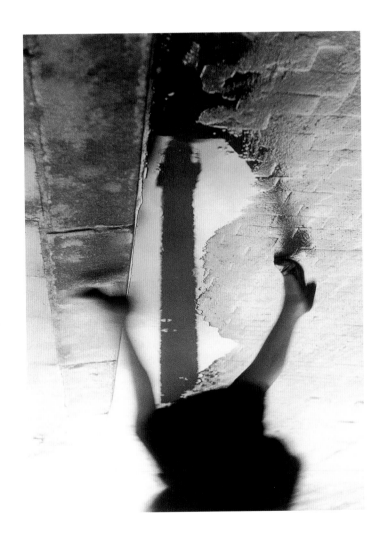

Plate 6

PLACE VENDÔME, PARIS, 1947

Willy Ronis

Plate 7

EASTER PARADE, HARLEM, 1947

Henri Cartier-Bresson

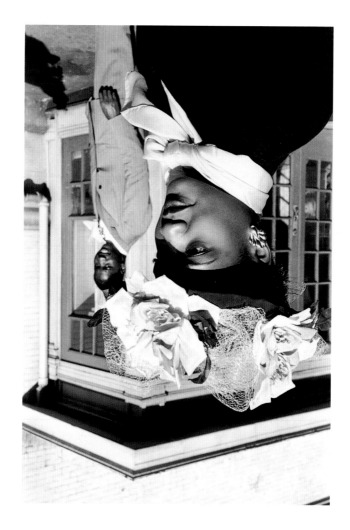

Plate 8

AUDREY HEPBURN ON THE SET OF *SABRINA*, 1953

Dennis Stock

Ruth Bernhard

PERSPECTIVE II, 1967

Plate 9

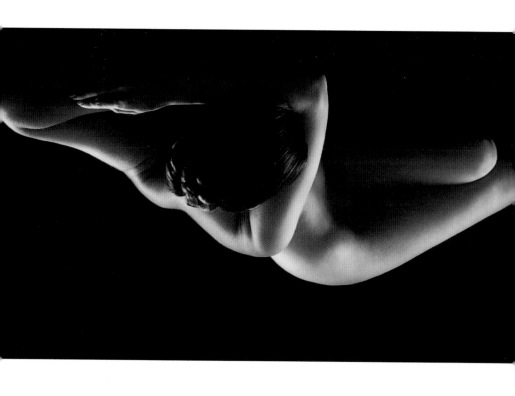

Plate 10

GOODBYE, 1942

Bert Hardy

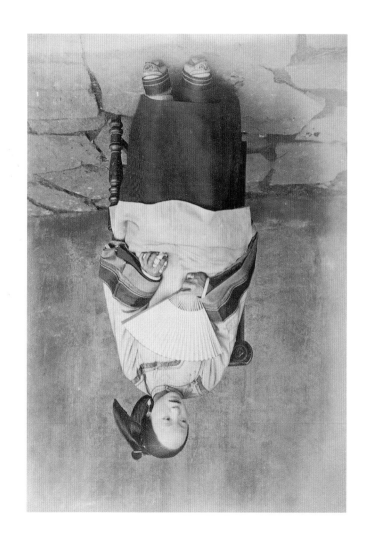

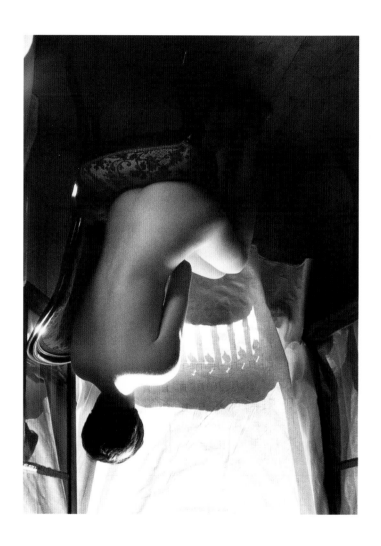

Plate 12

NU DE DOS, 1955

Willy Ronis

Plate 13

IN MEMORIAM, 1906

Edward Steichen

Plate 14

THE ORCHARD, 1905

Clarence White

Plate 15

PORTRAIT OF A WOMAN, 1919

William Alcock

THE MOURNING VEIL, 1904

George Seeley

Plate 17

GRIEF, c. 1860

Oscar Gustave Rejlander

Plate 18

THE BURNING OF ROME, 1907

George Seeley

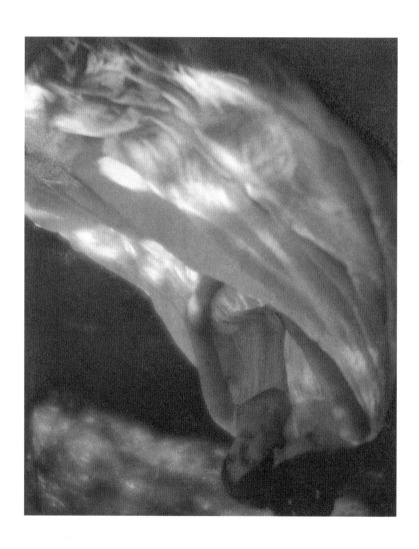

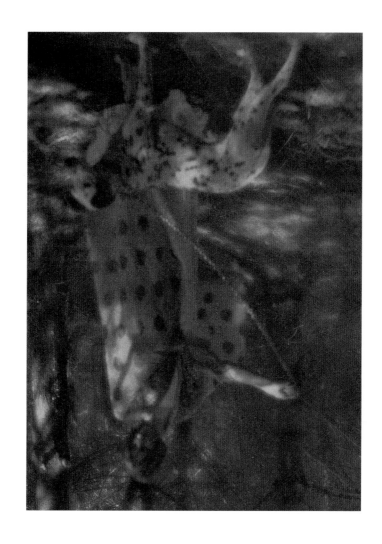

Plate 20

UNTITLED NUDE, c. 1905

Thomas O'Connor Sloane

Plate 21

BOLSHOI BALLET SCHOOL, MOSCOW, 1958

Cornell Capa

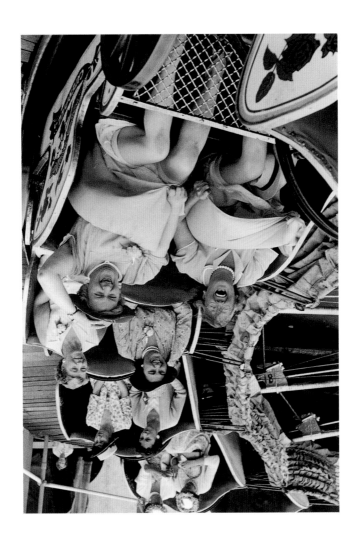

FUN FAIR, 1938

Kurt Hutton

Plate 24

MARY PICKFORD IN HER WEDDING DRESS, 1920

Baron De Meyer

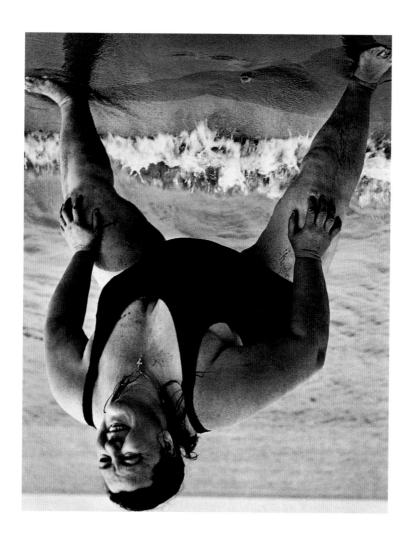

Plate 26

NUIT AU CHALET, 1935

Willy Ronis

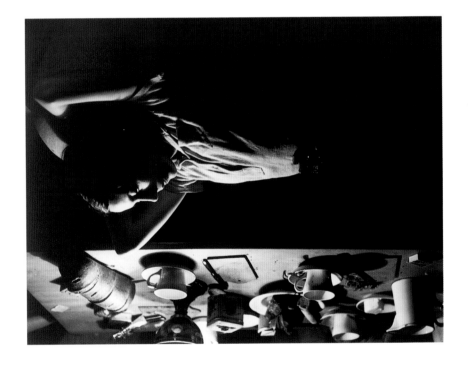

Plate 27

ELLA FITZGERALD, 1940

Carl van Vechten

Plate 28

MARTINE'S LEGS, 1968

Henri Cartier-Bresson

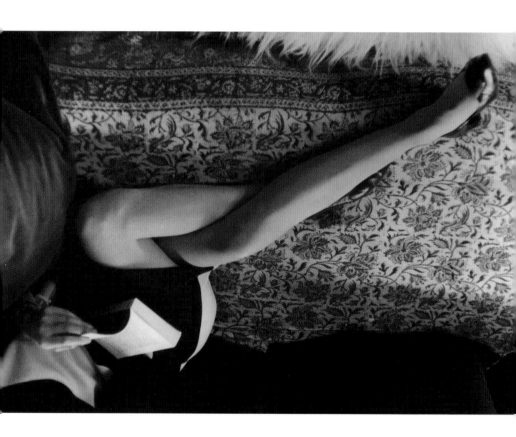

Plate 29

GRETA GARBO, 1931

Clarence Sinclair Bull

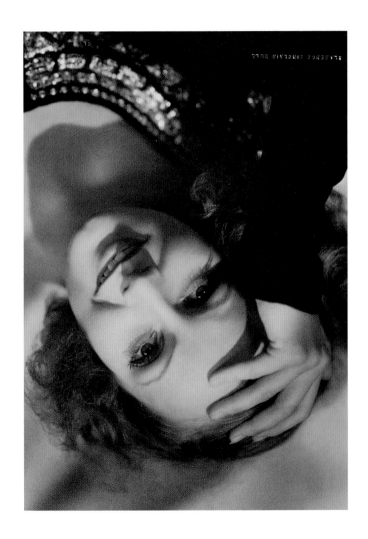

Plate 30

JUDY GARLAND, *A STAR IS BORN*, 1954

Bob Willoughby

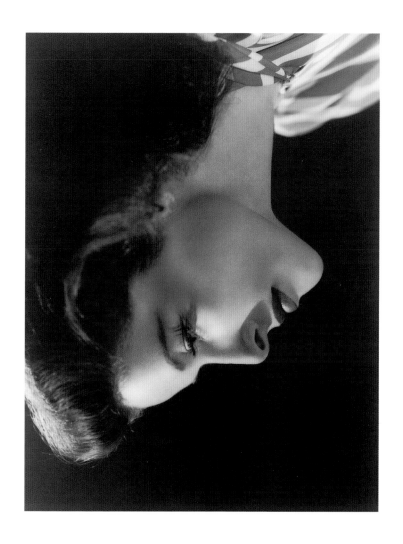

Plate 32

FISHER GIRL, 1914

Nancy Ford Cones

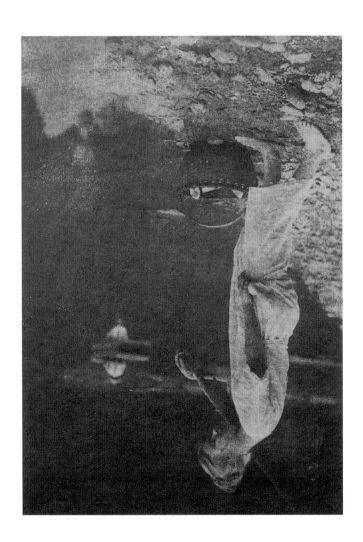

Plate 33

MOTHER & CHILD, ETHIOPIA, 1984

Sebastião Salgado

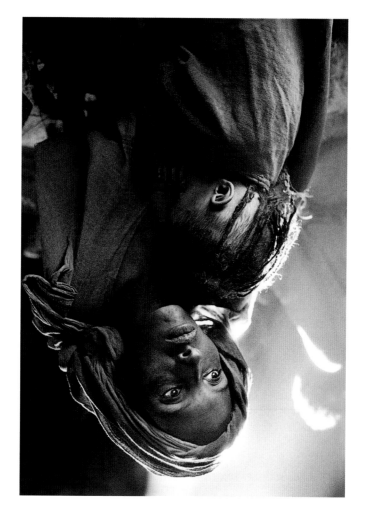

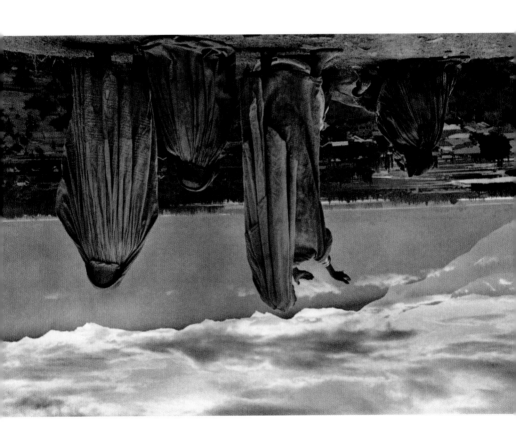

Plate 34

SRINAGAR, 1948

Henri Cartier-Bresson

Plate 35

LELLA, 1947

Edouard Boubat

Plate 36

LISBON, 1959

Henri Cartier-Bresson

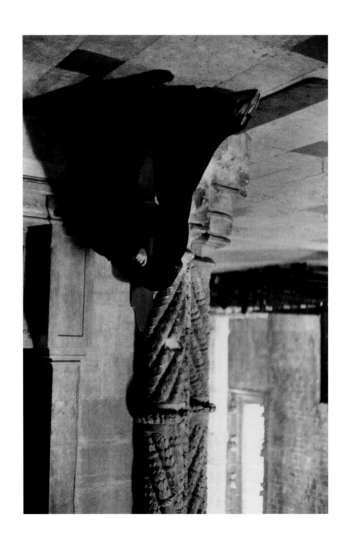

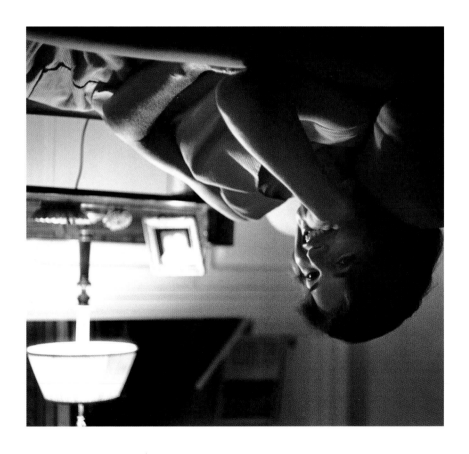

Plate 37

JACQUELINE KENNEDY, 1963

Mark Shaw

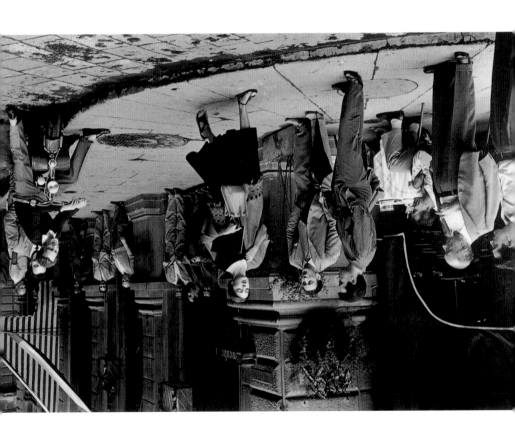

Plate 39

LA BOULANGÈRE, PARIS, 1960

Edouard Boubat

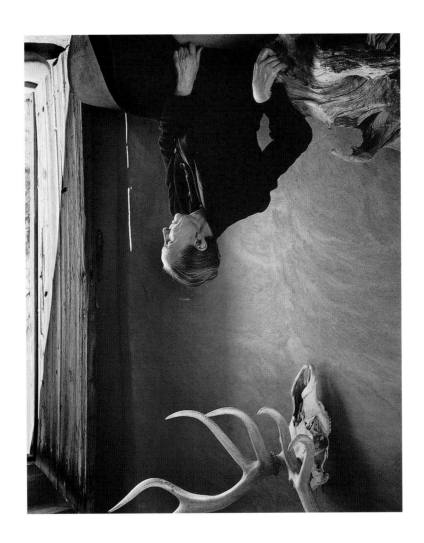

Plate 41

HELEN KELLER, 1948

Yousef Karsh

Plate 42

SARAH VAUGHAN, 1950

Popsie Randolph

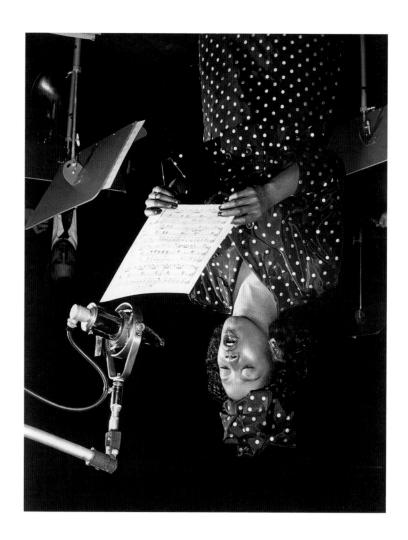

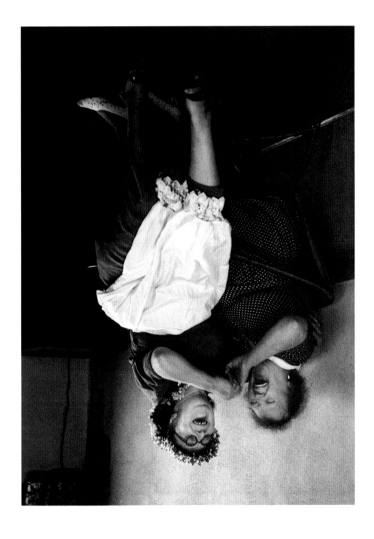

Plate 43

MOTHER'S PUB OUTING, 1954

Grace Robertson

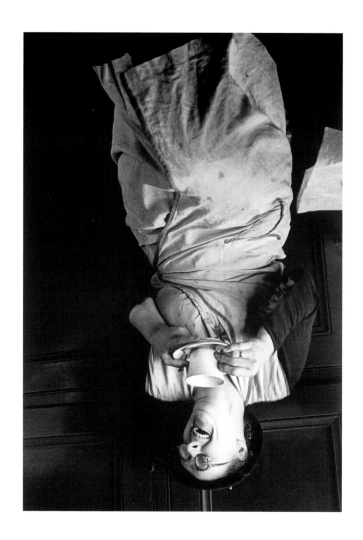

Plate 44

FÜN TEA BREAK, 1939

Gerti Deutsch

Plate 45

CAFÉ METROPOLE, NEW YORK, c. 1946

Lisette Model

Plate 46

DUST STORM, DURANGO COLONY, MEXICO, 1994

Larry Towell

Plate 48

MODELS IN WINDOW, NEW YORK, 1960

Ormond Gigli

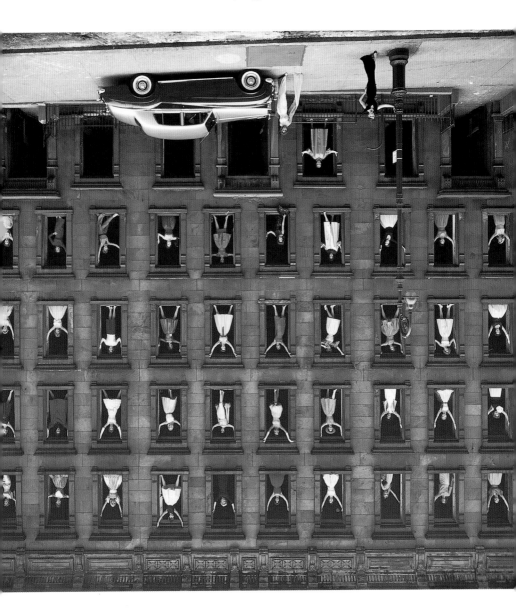

BACKSTAGE AT THE FOLIES BERGÈRE, PARIS, 1960

Jean-Philippe Charbonnier

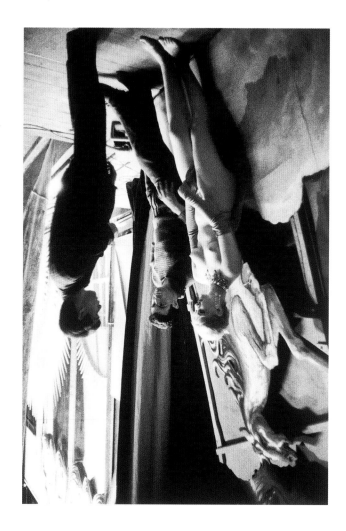

Plate 50

PHILIPPINE WOMAN, c. 1880

Anonymous

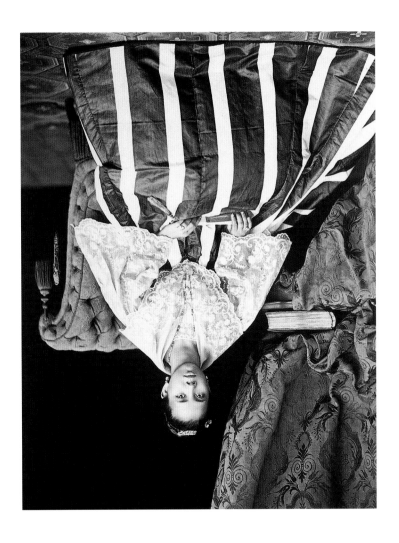

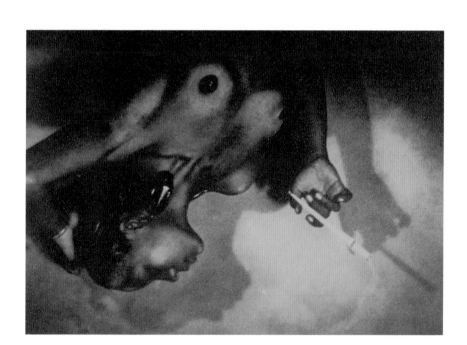

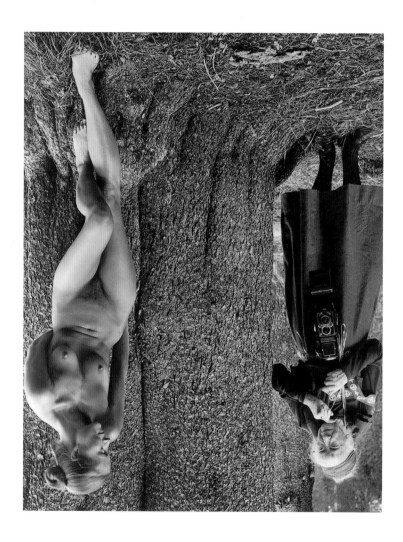

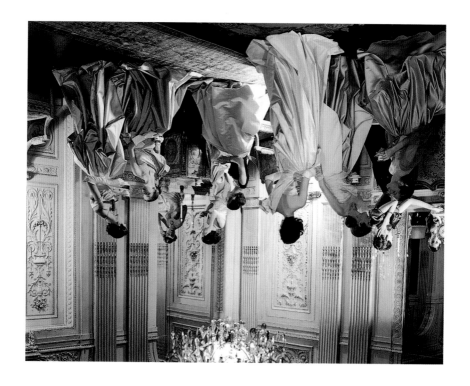

Plate 53

CHARLES JAMES DRESSES, 1948

Cecil Beaton

FLORIDA MIGRATORY FARM WORKER, NORTH CAROLINA, c. 1940

Plate 54

Plate 55

INDOCHINE WOMAN, c. 1880

Emil Gsell

Plate 56

BIBI IN LONDON, 1919

Jacques-Henri Lartigue

Plate 57

BILLIE HOLIDAY, NEW YORK CITY, 1949

Herman Leonard

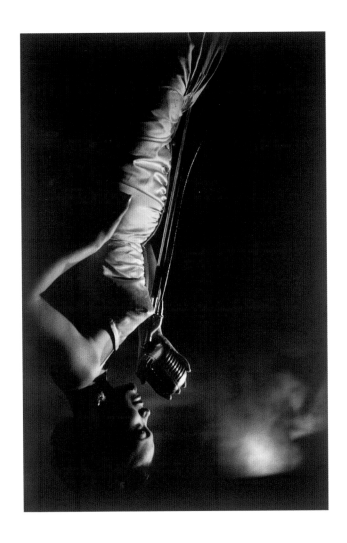

Plate 58

EARTHA KITT, NEW YORK, 1952

Ernst Haas

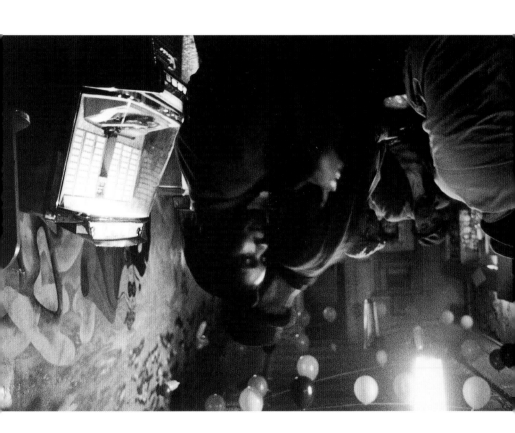

Plate 59

CHICAGO, 1962

Bruce Davidson

Plate 60

NAMDINH, INDOCHINA, 1954

Robert Capa

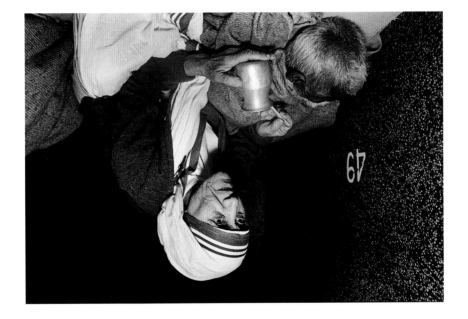

Plate 62

SHE IS A TREE OF LIFE TO THEM, 1950

Consuelo Kanaga

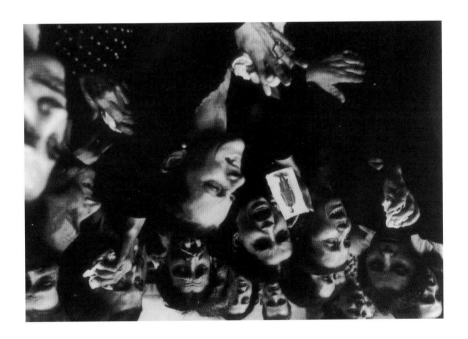

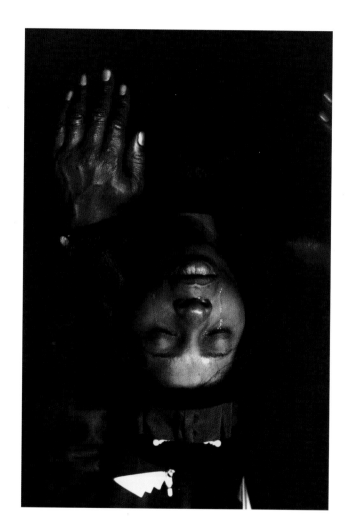

LA ROSA, 1989

Luis González Palma

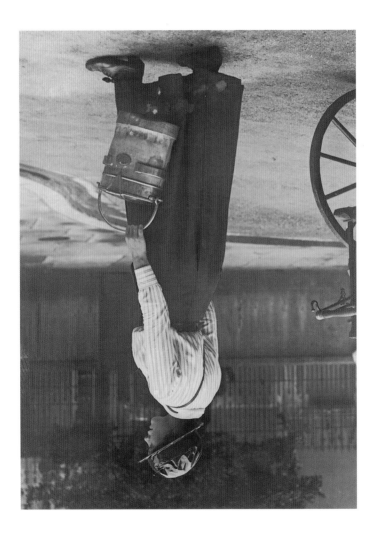

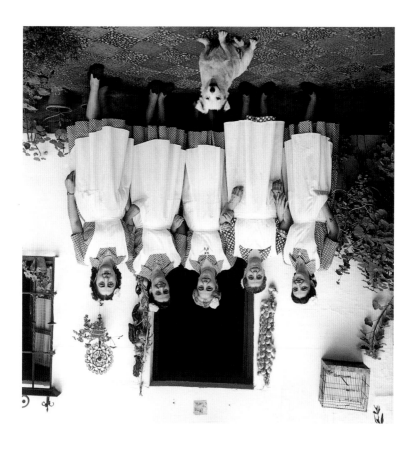

Plate 67

SPANISH MAIDS, GRANADA, 1950

Jean-Philippe Charbonnier

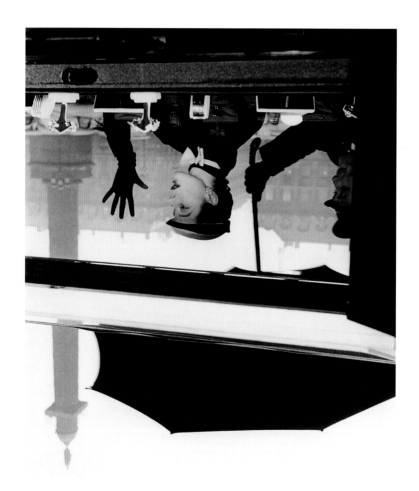

Plate 68

BETTINA, THE FAIREST, PARIS, 1953

Jean-Philippe Charbonnier

Plate 69

"THE KISS," GRAND CENTRAL STATION, NEW YORK, 1958

Ernst Haas

Plate 70

MOTHER AND CHILD, 1898

Gertrude Käsebier

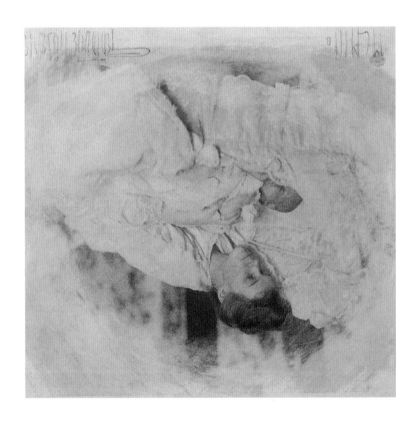

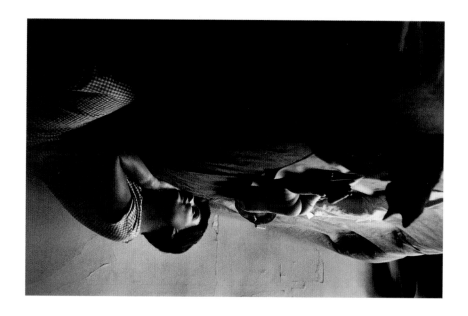

Plate 71

NEW YORK, 1953

Elliott Erwitt

Plate 72

LES FRITES, PARIS, 1946

Willy Ronis

Plate 73

CHEERLEADER, GILLSPORT, MISSISSIPPI, 1954

Elliott Erwitt

Plate 74

MORNING RUSH HOUR, SAN FRANCISCO, 1950

Cameron Macauley

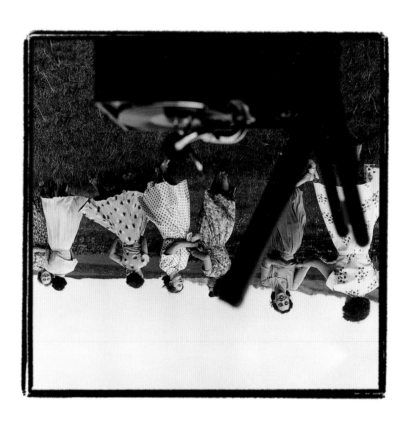

Plate 75

COUNTRY DANCING, 1953

Ronald Startup

Plate 76

HOME, 1912

Jach Janusz Bulhak

Plate 77

LITTLE COUSIN, 1907

Nancy Ford Cones

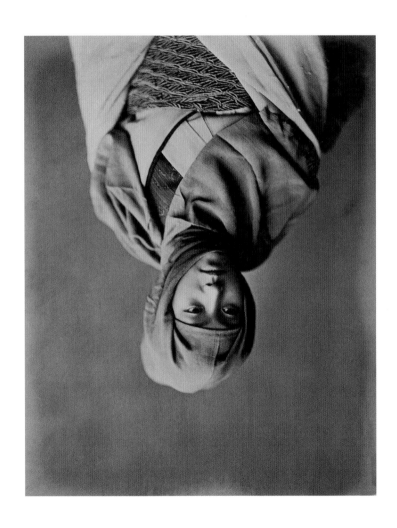

Plate 78

YOUNG JAPANESE WOMAN, c. 1880

Felice Beato

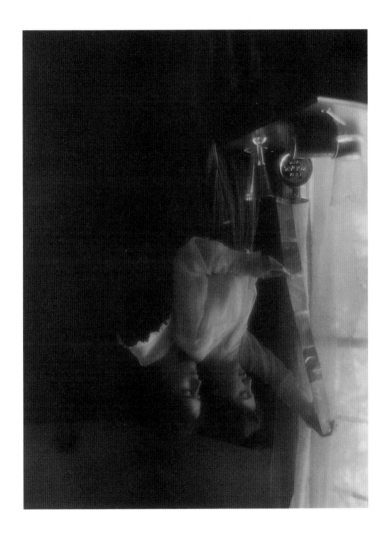

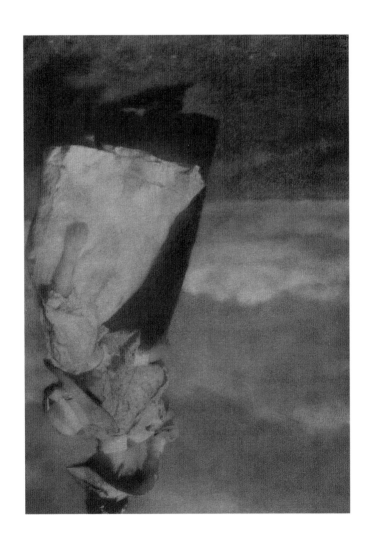

Plate 81

GOSSIPING BY THE WATER, 1916

William Gordon Shields

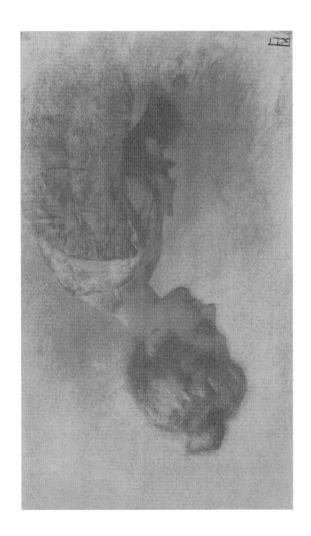

Plate 82

SOLITUDE, c. 1890

Robert Demachy

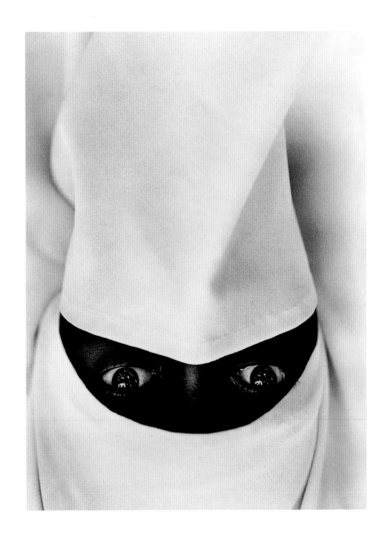

Plate 83

YOUNG MOSLEM WOMAN, BROOKLYN, 1990

Chester Higgins Jr.

Plate 84

A COUNTRY ROAD, 1915

Paul Anderson

COLETTE, PARIS, 1953

Plate 86

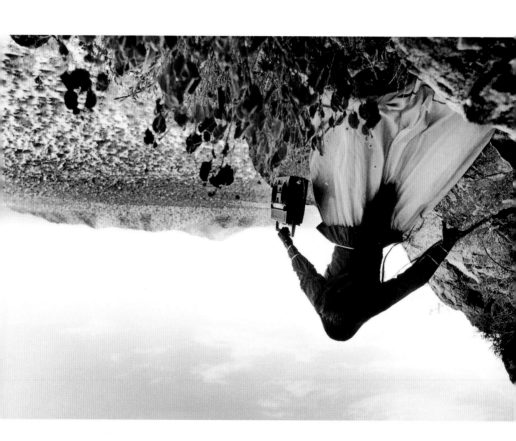

Plate 87

MUJER ÁNGEL, 1979

Graciela Iturbide

Plate 88

MANCHU WOMAN NURSING, 1903

August Francois

Plate 89

MY EWEN'S BRIDE, 1869

Julia Margaret Cameron

Plate 90

SELF PORTRAIT, 1932

Alma Lavenson

Plate 91

PORTRAIT, c. 1904

Anonymous

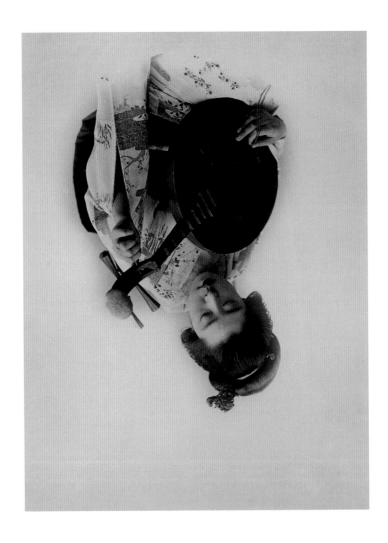

Plate 92

PORTRAIT OF A YOUNG JAPANESE WOMAN, c. 1870

Anonymous

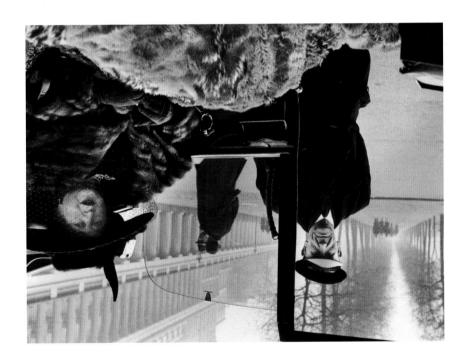

Inge Morath

MRS. EVELYN NASH, LONDON, 1953

Plate 93

MANCHESTER UNIVERSITY STUDENTS AT A UNION DANCE, 1955

Plate 94

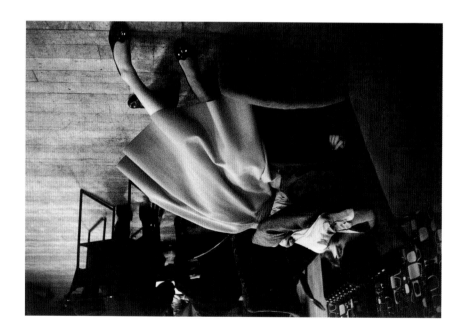

Plate 95

MAIDENS IN WAITING, 1951

Bert Hardy

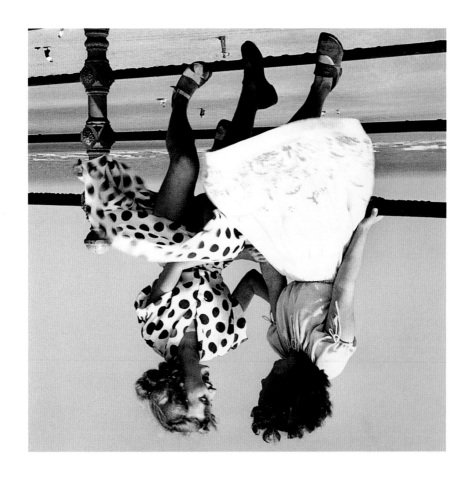

Plate 96

DANCING PARTY, c. 1870

Kusabei Kimbei

Plate 97

WIFE OF THE COLOGNE PAINTER PETER ABELEN, 1926

August Sander

SARAH BERNHARDT, 1880

Napoleon Sarony

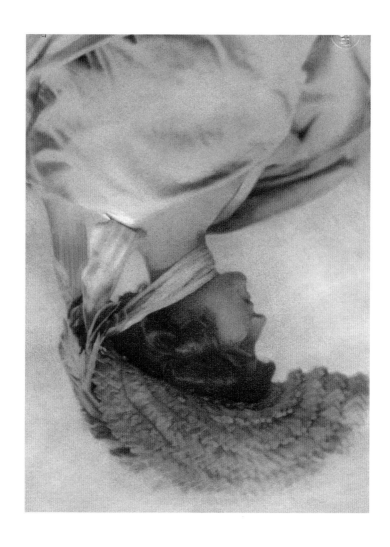

Plate 99

THE STRAW HAT, 1906

Constant Puyo

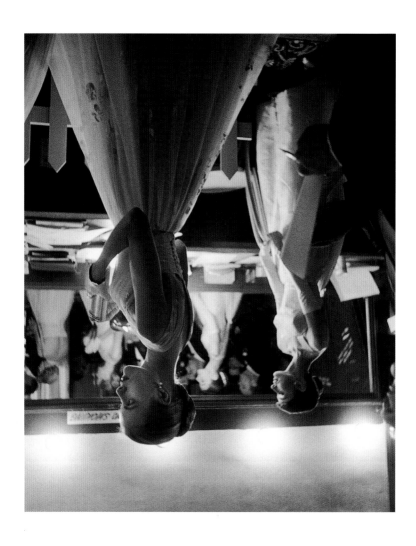

Plate 100

AUDREY HEPBURN & GRACE KELLY BACKSTAGE AT THE 28TH ANNUAL ACADEMY AWARDS, 1956

Allan Grant

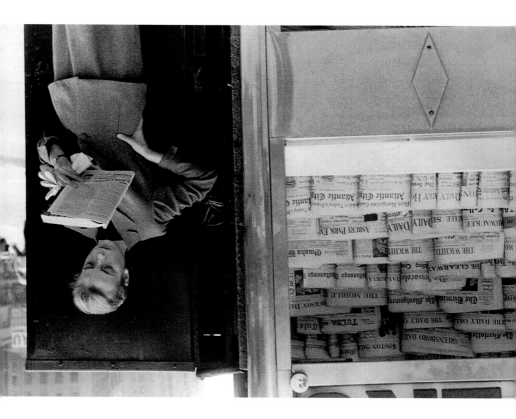

Plate 101

ELBOWING AN OUT OF TOWN NEWS STAND, NEW YORK, 1954

Louis Stettner

MARGUERITE DILLEMUTH, 1946

Plate 102

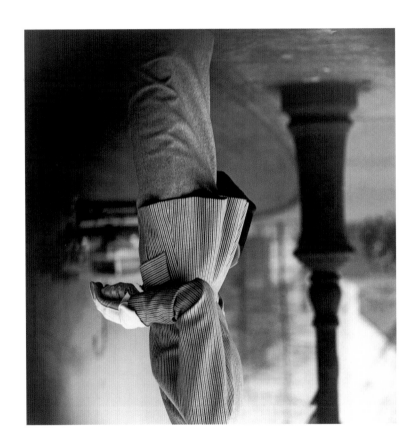

Plate 103

THE VIOLINIST, c. 1910

John F. Bullock

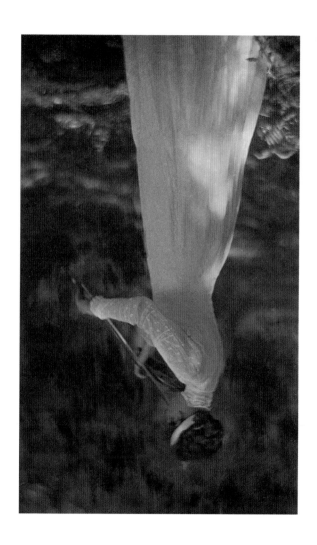

Plate 104

PLATE 405 HUMAN AND ANIMAL LOCOMOTION, c. 1879

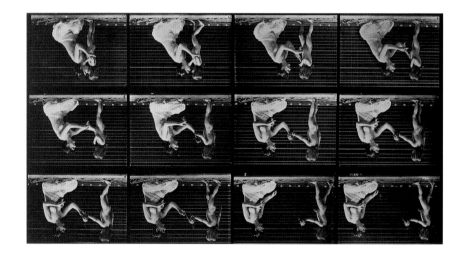

Plate 105

MOTHER & CHILD, c. 1901

Howard Beach

Plate 106

EL SILENCIO, 1998

Luis González Palma

Plate 107

WOMEN OF SANTA ANNA, MICHOACAN, MEXICO, 1933

Paul Strand

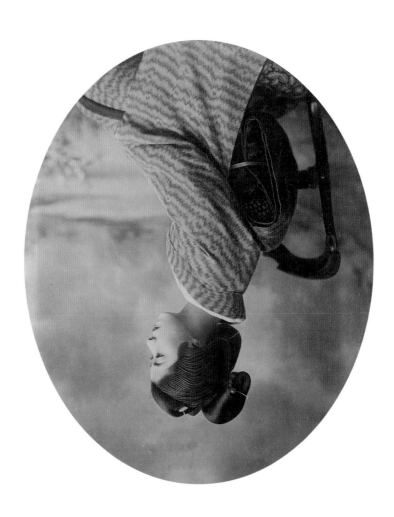

Plate 109

TUSCANY, 1956

Edouard Boubat

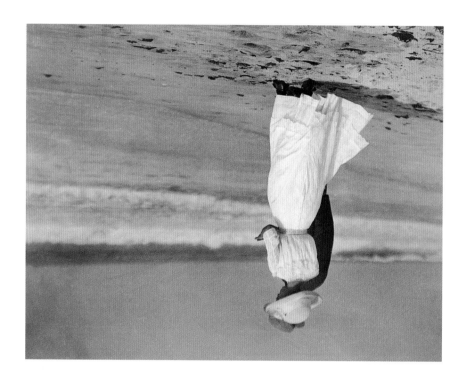

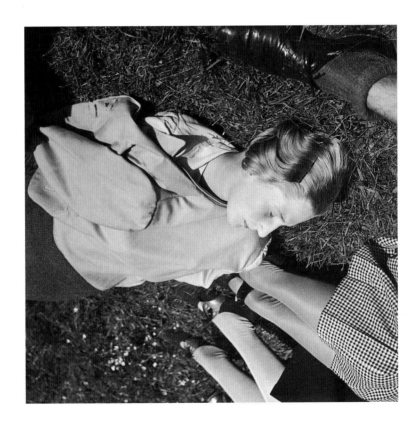

Plate III

SUMMER, 1935

Josef Ehm

TORSO, 1909

Clarence H. White and Alfred Stieglitz

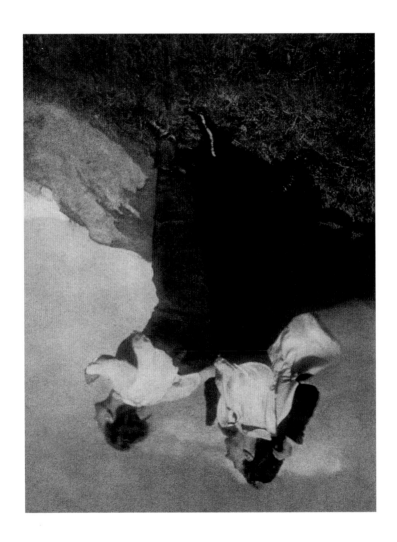

Plate 115

Nº TWO MADONNA, 1932

Arnold Genthe

Plate 116

THE DAYDREAM, 1931

Manuel Alvarez Bravo

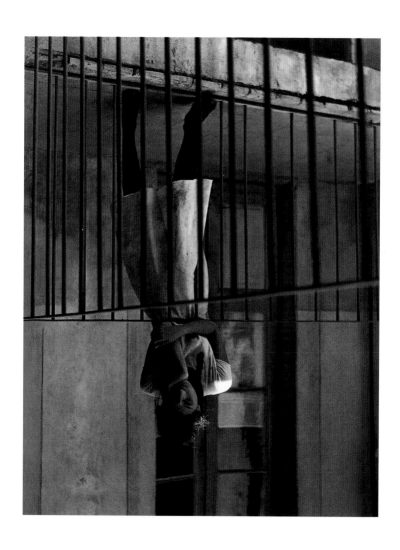

Plate 117

DRYING CLOTH, VIETNAM, 1970

Don Hong Oai

Plate 118

DANCER, RYUKU ISLANDS, 1957

Hiroshi Himaya

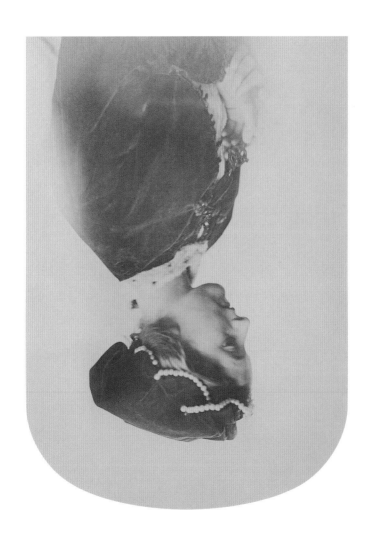

Oscar Gustave Rejlander

PORTRAIT OF A WOMAN, c. 1860

Plate 119

Plate 120

PABLO PICASSO & FRANÇOISE GILOT, GOLFE-JUAN, FRANCE, 1948

Robert Capa